# Simply Knowing GOD

## A Heart's Journey

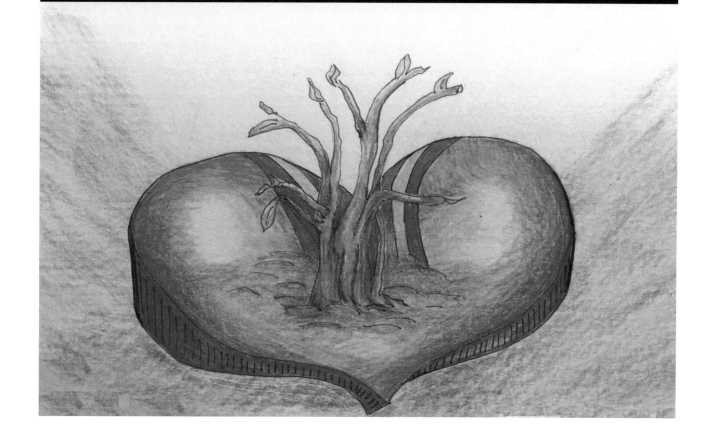

## Janet Darnell

WestBow Press books may be ordered through booksellers or by contacting:

WestBow Press
A Division of Thomas Nelson & Zondervan
1663 Liberty Drive
Bloomington, IN 47403
www.westbowpress.com
1 (866) 928-1240

Because of the dynamic nature of the Internet, any web addresses or links contained in this book may have changed since publication and may no longer be valid. The views expressed in this work are solely those of the author and do not necessarily reflect the views of the publisher, and the publisher hereby disclaims any responsibility for them.

Any people depicted in stock imagery provided by Thinkstock are models, and such images are being used for illustrative purposes only.
Certain stock imagery © Thinkstock.

ISBN: 978-1-5127-2471-4 (sc)
ISBN: 978-1-5127-2470-7 (e)

Library of Congress Control Number: 2015920998

Print information available on the last page.

WestBow Press rev. date: 12/30/2015

WESTBOW
PRESS®
A DIVISION OF THOMAS NELSON
& ZONDERVAN

# DEDICATION

*This book is dedicated to my mother and father. Thanks for buying me crayons and coloring books, letting me watch Saturday morning cartoons, and for taking me to Sunday School!*

# ACKNOWLEDGEMENTS

*Many thanks to all of my dear friends for encouraging me these years. Thanks to my friends at the Shrine of Divine Mercy Prayer Group (Stockbridge, MA) and the Sisters of the Visitation (Tyringham, MA) for their prayers and support.*

# Contents

# Introduction

***Stop, Look, and Listen! Listen Janet, Listen!***

These are the words I heard during a prayer time prior to our team leaving Hawaii for our outreach to an Asian country. Accompanying me on that trip were a sketchbook, headphones, and a set of colored pencils. Early each morning I sketched and colored in response to sitting with the Lord and listening to the worship music, which encouraged my heart. My art has continued to be an expression of my quiet times with Him. These drawings represent some of my heart's journey, experiencing God's loving heart and His healing, as I became willing to step out of my comfort zone.

Each step I took, He took three. If I gave Him one glance, He ran around me waving his arms saying "I love you." I found that if one is willing to have a desire to be healed and to go beyond one's hurt and wounds, then He is there waiting to rush in with healing and comfort. Sometimes the healing process is fast. Most often the process is longer because each one of us is like an onion with many layers and His healing is designed to meet each one's uniqueness. At times I felt like I had been healed of some hurt, only to realize later that the wound was much deeper than I was aware. In His loving care the Lord continued to bring me to deeper and deeper levels of healing.

Our God is awesome! He is Love! He is a good dad! Jesus is an amazing Savior and friend! Holy Spirit is a wonderful counselor and guide. God in His fullness is fun! The older I get, the more God's love, grace and mercy are becoming more and more simple. He continues to encourage me to come to Him as a child in simplicity: Simple faith – simple drawings.

May you hear God's voice, as you, one of His wonderful creations, walk through this gallery of A Heart's Journey.

# 1 - Pit Test

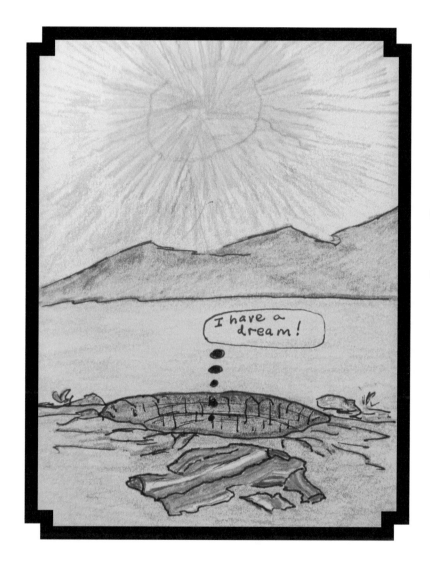

He brought me up also out of an horrible pit, out of the miry clay, and set my feet upon a rock, and established my goings.

And he hath put a new song in my mouth, even praise unto our God: many shall see it, and fear, and shall trust in the LORD.

Psalms 40:2-3 (King James Version (KJV))

# 2 - What a Drag!

Stand fast therefore in the liberty wherewith Christ hath made us free, and be not entangled again with the yoke of bondage.

Galatians 5:1 (KJV)

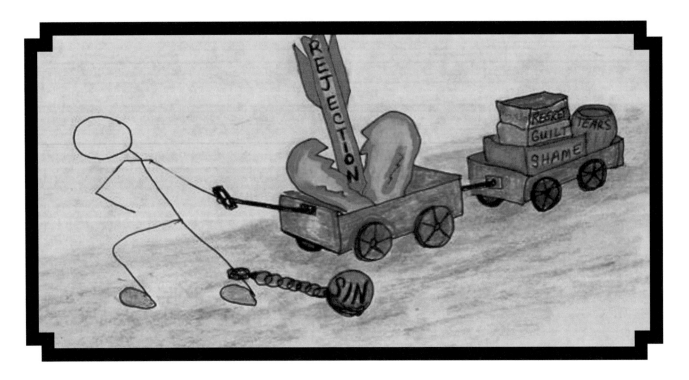

# 3 - Incoming!

... I am pained at my very heart; my heart maketh a noise
in me; I cannot hold my peace, because thou hast heard,
O my soul, the sound of the trumpet, the alarm of war.

Jeremiah 4:19 (KJV)

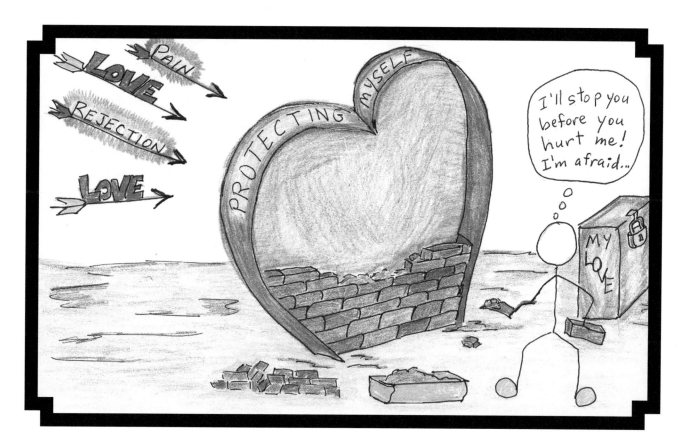

# 4 - Pruned

Behold, I will do a new thing; now it shall spring forth; shall ye not know it? I will even make a way in the wilderness, and rivers in the desert.

Isaiah 43:19 (KJV)

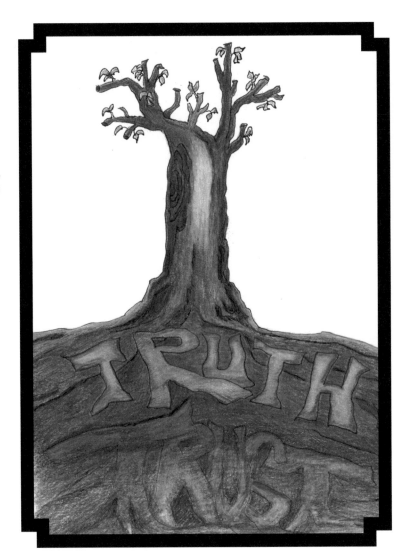

# 5 - Open Gates

Keep thy heart with all diligence; for
out of it are the issues of life.

Proverbs 4:23 (KJV)

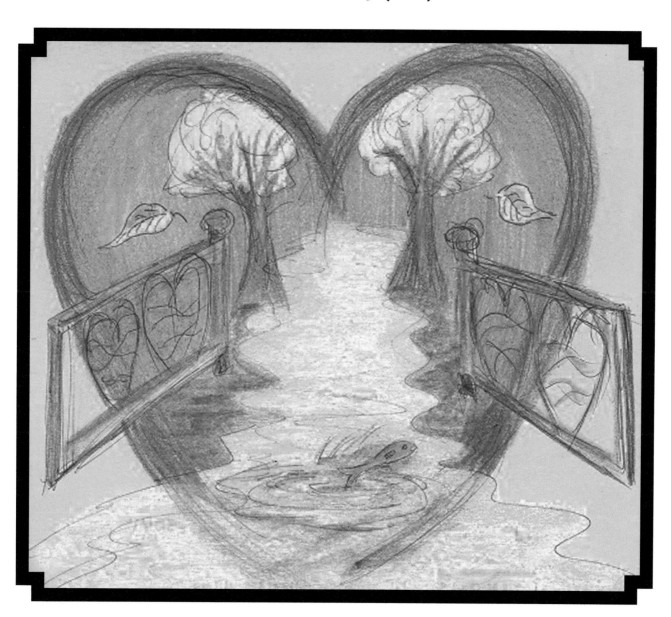

# 6 - Your Light - My Healing

The LORD is nigh unto
them that are of a
broken heart; and
saveth such as be of
a contrite spirit.

Psalms 34:18 (KJV)

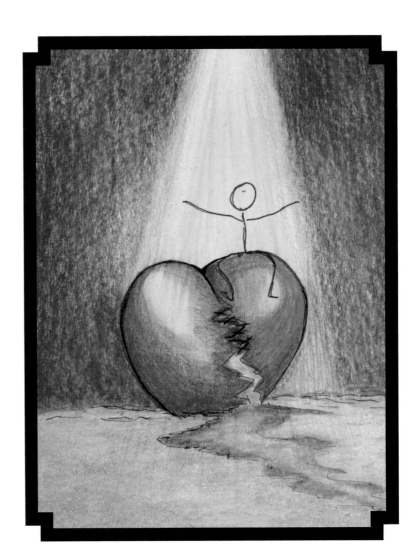

# 7 - Loving and Being Loved

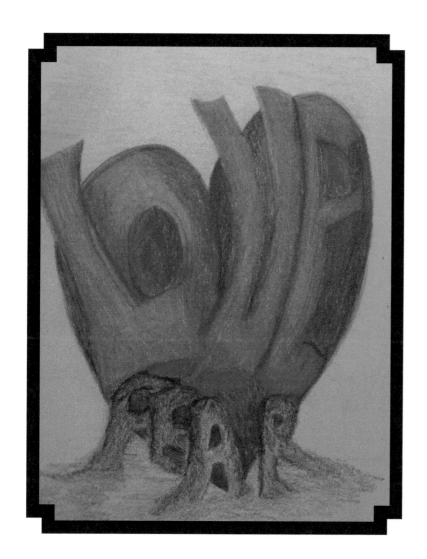

There is no fear in love; but perfect love casteth out fear: because fear hath torment. He that feareth is not made perfect in love.

I John 4:18 (KJV)

# 8 - Grace Garden

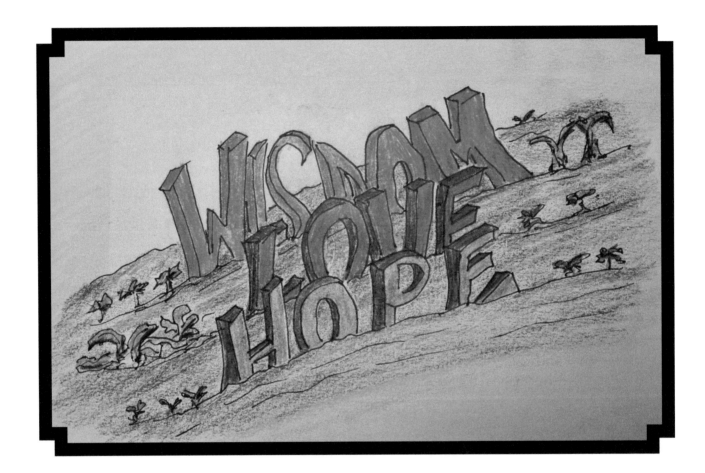

But grow in grace, and in the knowledge of
our Lord and Saviour Jesus Christ.

To him be glory both now and for ever. Amen.

II Peter 3:18 (KJV)

# 9 - A Necessary Ending

Brethren, I count not myself to have apprehended: but this one thing I do, forgetting those things which are behind, and reaching forth unto those things which are before, I press toward the mark for the prize of the high calling of God in Christ Jesus.

Philippians 3:13-14 (KJV)

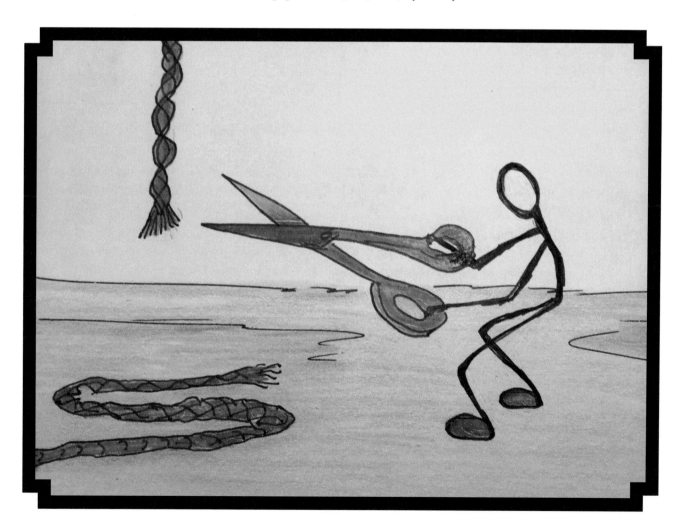

# 10 - New Mercies

It is of the LORD's mercies that we are not consumed,
because his compassions fail not. They are new
every morning; great is thy faithfulness.

Lamentations 3:22-23 (KJV)

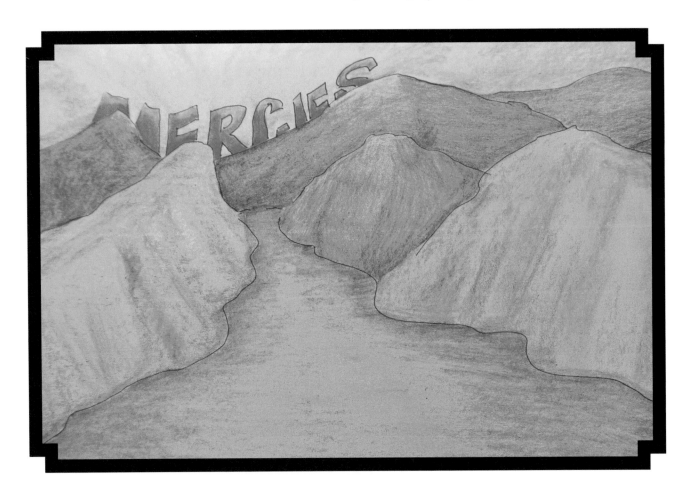

# 11 - Flourishing Heart

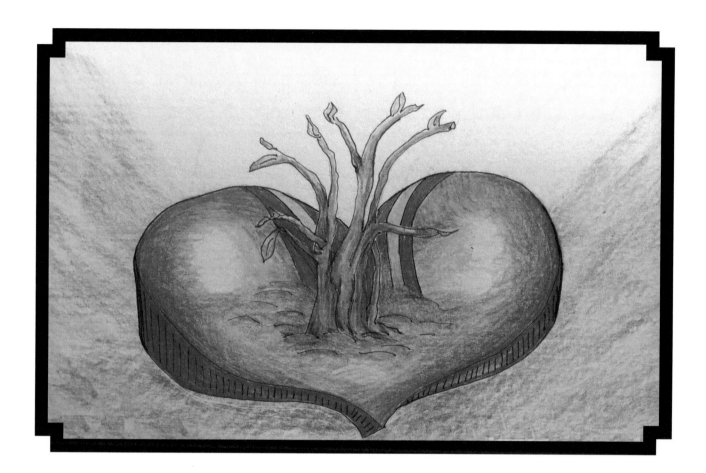

That Christ may dwell in your hearts by faith; that
ye, being rooted and grounded in love,

May be able to comprehend with all saints what is
the breadth, and length, and depth, and height;

And to know the love of Christ, which passeth knowledge,
that ye might be filled with all the fulness of God.

**Ephesians 3:17-19 (KJV)**

# 12 - A Watered Garden

And the LORD shall guide thee continually, and satisfy thy soul
in drought, and make fat thy bones: and thou shalt be like a
watered garden, and like a spring of water, whose waters fail not.

And they that shall be of thee shall build the old waste
places: thou shalt raise up the foundations of many
generations; and thou shalt be called, The repairer
of the breach, The restorer of paths to dwell in.

**Isaiah 58:11-12 (KJV)**

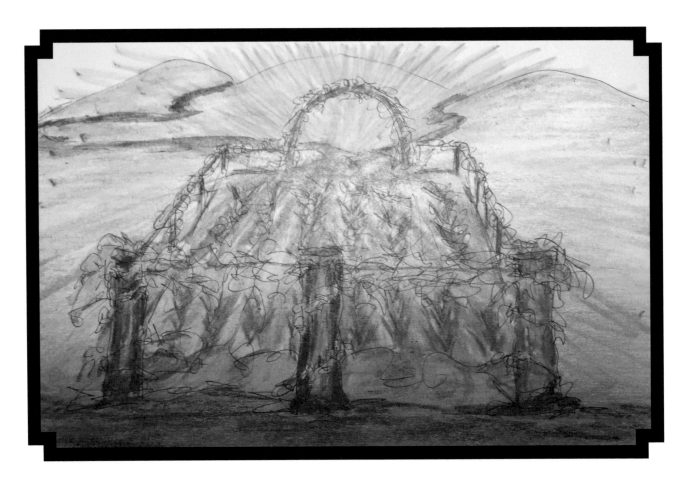

# 13 - Setting Your Hope

**Blessed be the God and Father of our Lord Jesus Christ, which according to his abundant mercy hath begotten us again unto a lively hope by the resurrection of Jesus Christ from the dead,**

**I Peter 1:3 (KJV)**

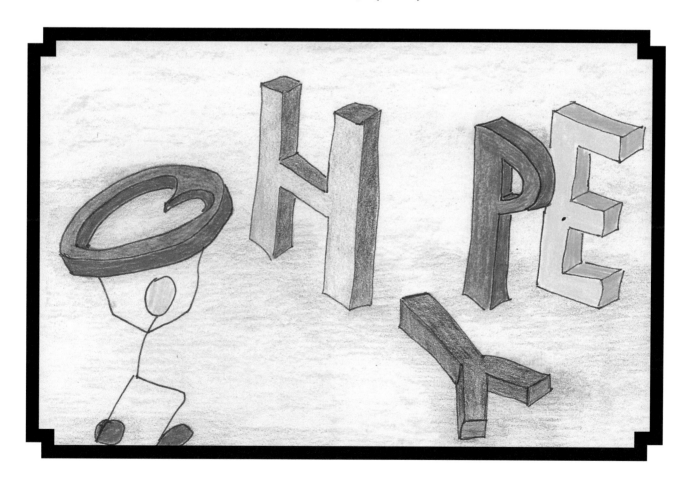

# 14 - Puzzled?

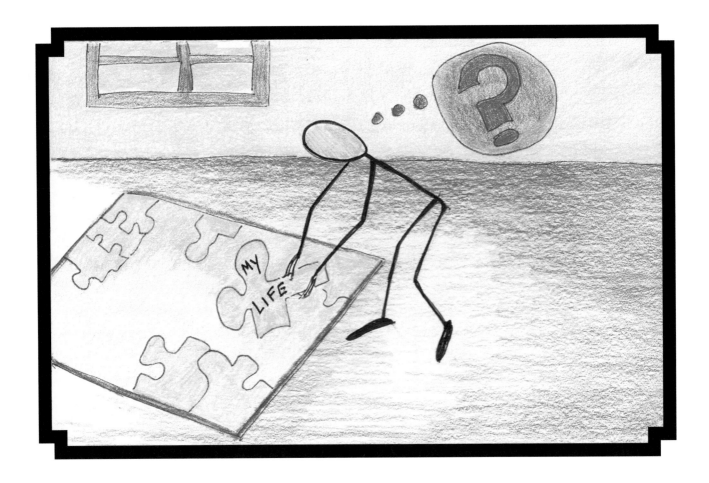

Howbeit when he, the Spirit of truth, is come, he
will guide you into all truth: for he shall not speak
of himself; but whatsoever he shall hear, that shall
he speak: and he will shew you things to come.

John 16:13 (KJV)

# 15 - And...They're...Off!

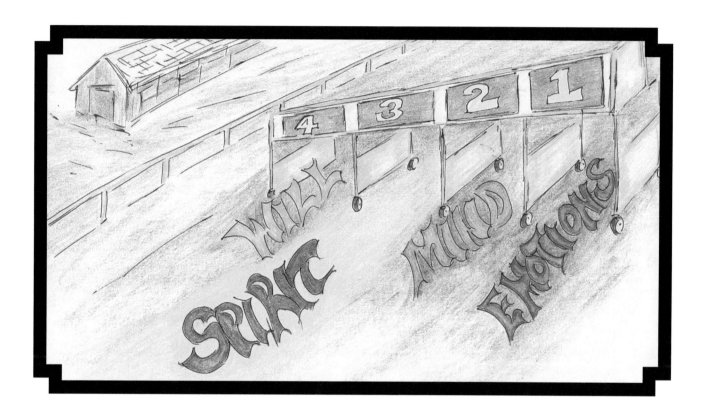

If we live in the Spirit, let us also walk in the Spirit.

Galatians 5:25 (KJV)

# 16 - Surrender!

I beseech you therefore, brethren, by the mercies of
God, that ye present your bodies a living sacrifice, holy,
acceptable unto God, which is your reasonable service. And
be not conformed to this world; but be ye transformed
by the renewing of your mind, that ye may prove what is
that good, and acceptable, and perfect, will of God.

**Romans 12:1-2 (KJV)**

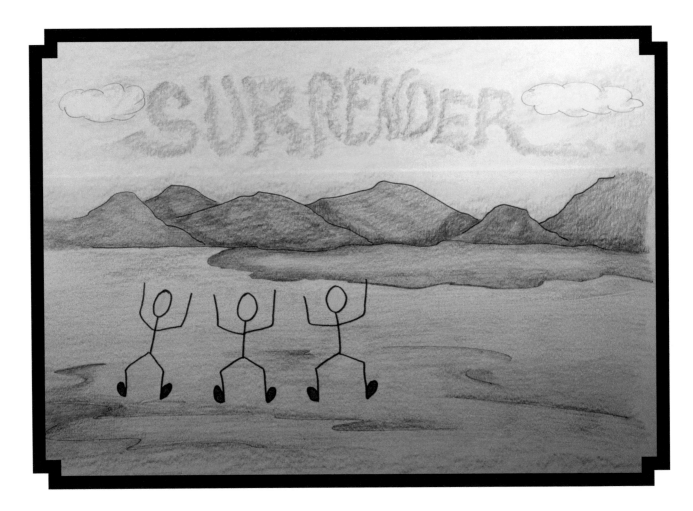

# 17 - Trust

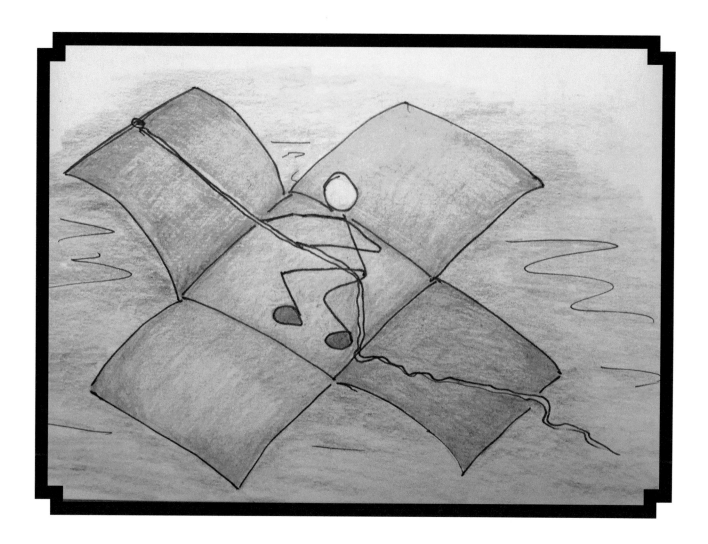

Trust in the LORD with all thine heart; and lean
not unto thine own understanding.

In all thy ways acknowledge him, and he shall direct thy paths.

**Proverbs 3:5-6 (KJV)**

# 18 - Back to the Future

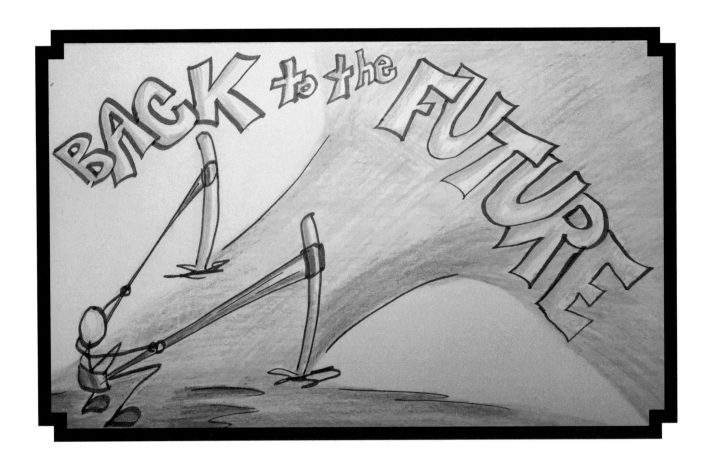

For I know the thoughts that I think toward you, saith the Lᴏʀᴅ, thoughts of peace, and not of evil, to give you an expected end. Then shall ye call upon me, and ye shall go and pray unto me, and I will hearken unto you. And ye shall seek me, and find me, when ye shall search for me with all your heart.

Jeremiah 29:11-13 (KJV)

# 19 - Stepping Stones

**Thy word is a lamp unto my feet,**
**and a light unto my path.**

**Psalm 119.105 (KJV)**

# 20 - Stepping Up to My Plate

I will praise thee; for I am fearfully and wonderfully made:
marvellous are thy works;
and that my soul knoweth right well.

Psalms 139:14 (KJV)

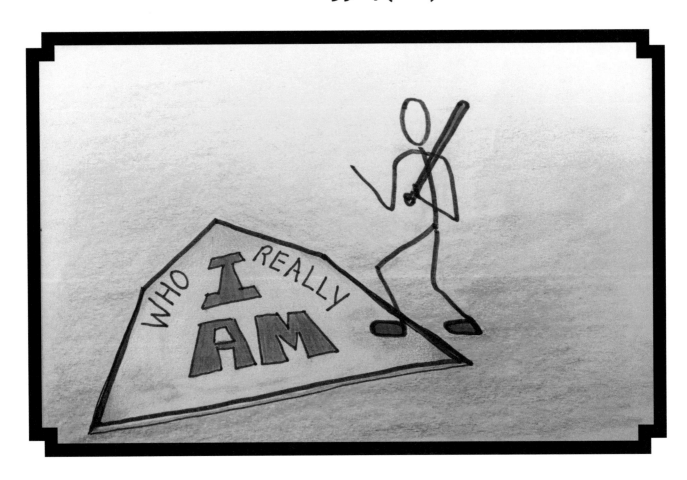

# 21 - Reflection

But we all, with open face beholding as in a glass the glory of the Lord, are changed into the same image from glory to glory, even as by the Spirit of the Lord.

**II Corinthians 3:18 (KJV)**

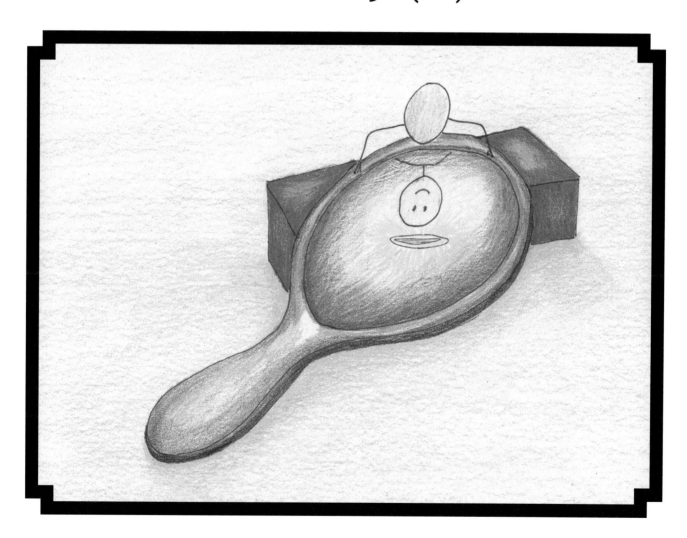

# 22 - Hope-Fully Waiting

And now, Lord, what wait I for? my hope is in thee.

Psalms 39:7 (KJV)

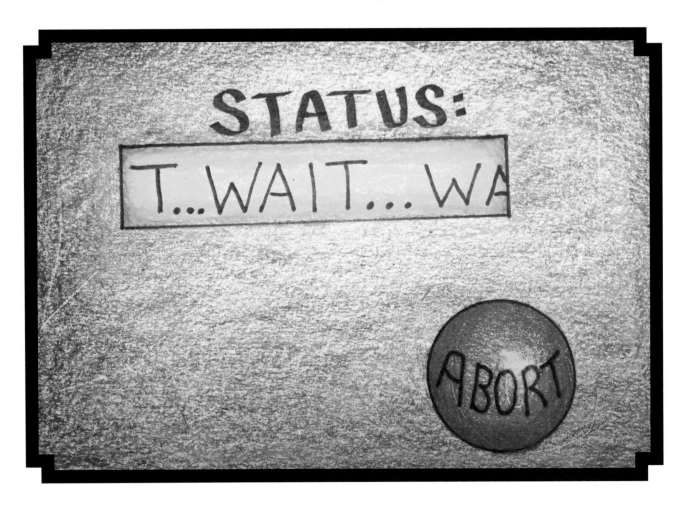

But if we hope for that we see not, then
do we with patience wait for it.

Romans 8:25 (KJV)

# 23 - I've Got This!

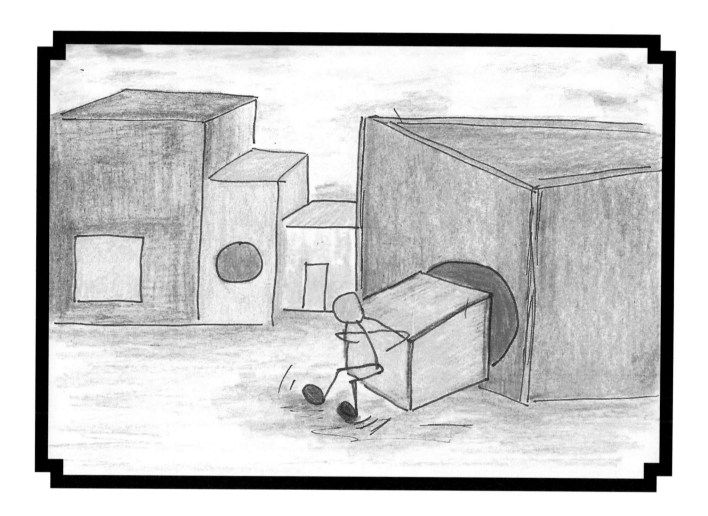

**Wait on the LORD; be of good courage, and he shall strengthen thine heart; wait, I say, on the LORD.**

**Psalm 27:14 (KJV)**

# 24 - Just When I Thought

**A man's heart deviseth his way:**
**but the LORD directeth his steps.**

**Proverbs 16:9 (KJV)**

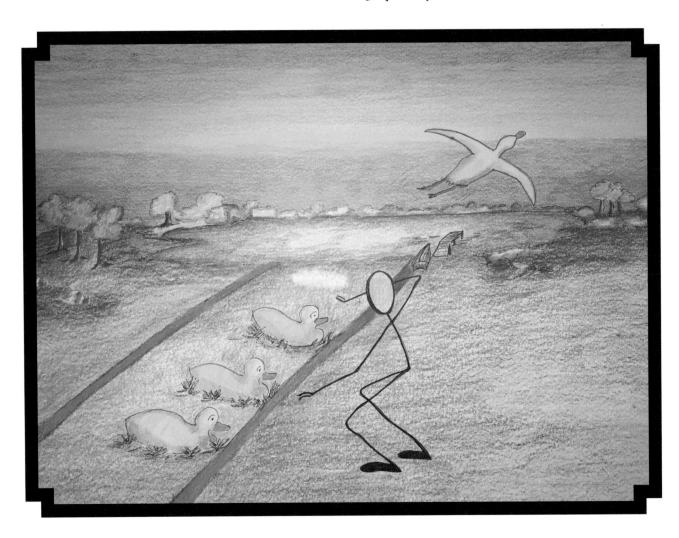

# 25 - Washing of the Word

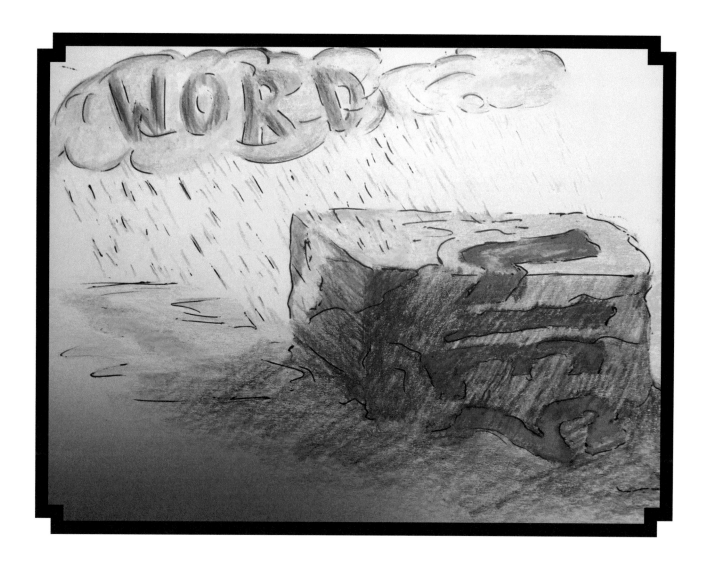

"He answered and said, A man that is called Jesus made clay, and anointed mine eyes, and said unto me, 'Go to the pool of Siloam, and wash; and I went and washed, and I received sight.'"

John 9:11 (KJV)

# 26 - Jesus Heals the Brokenhearted

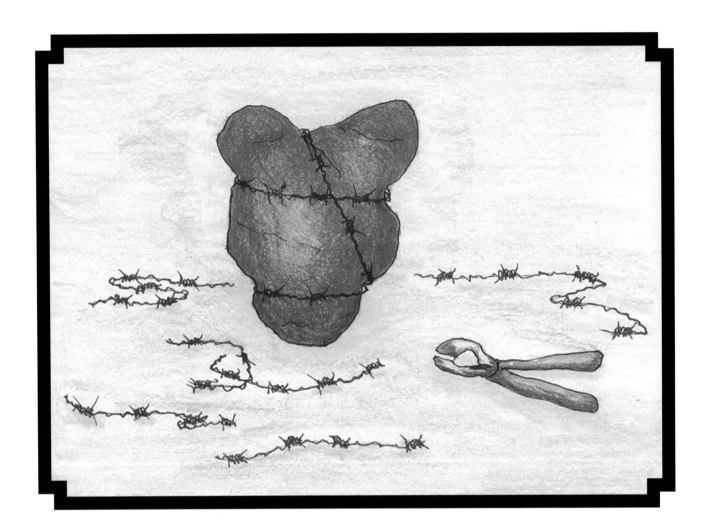

The thief cometh not, but for to steal, and to kill,
and to destroy; I am come that they might have life,
and that they might have it more abundantly.

**John 10:10 (KJV)**

# 27 - Freely Appointed

Take my yoke upon you, and learn of me; for I am meek and lowly in heart; and ye shall find rest unto your souls. For my yoke is easy, and my burden is light.

Matthew 11:29-30 (KJV)

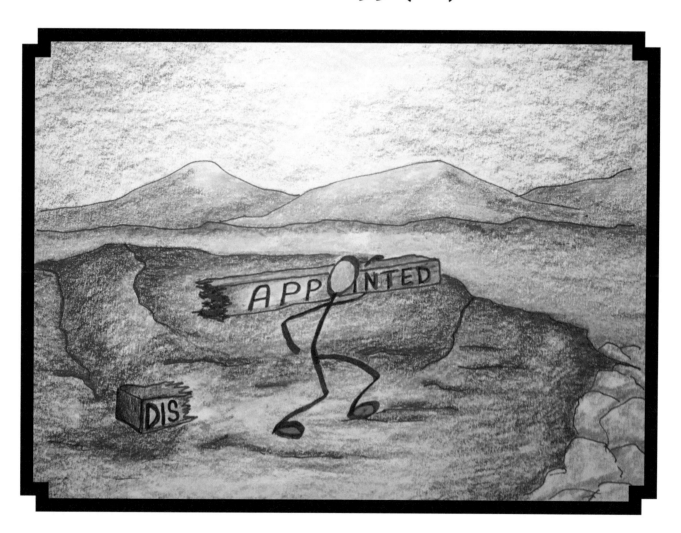

# 28 - Freedom from Fear

For God hath not given us the spirit of fear; but
of power, and of love, and of a sound mind.

II Timothy 1:7 (KJV)

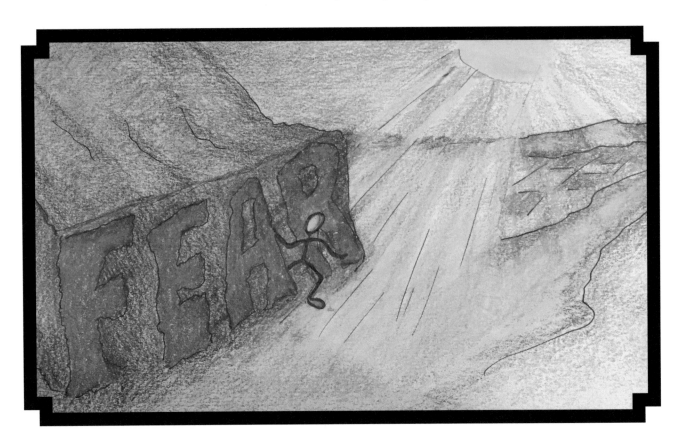

# 29 - Pure Joy!

Looking unto Jesus the author and finisher of our faith; who for the joy that was set before him endured the cross, despising the shame, and is set down at the right hand of the throne of God.

Hebrews 12:2 (KJV)

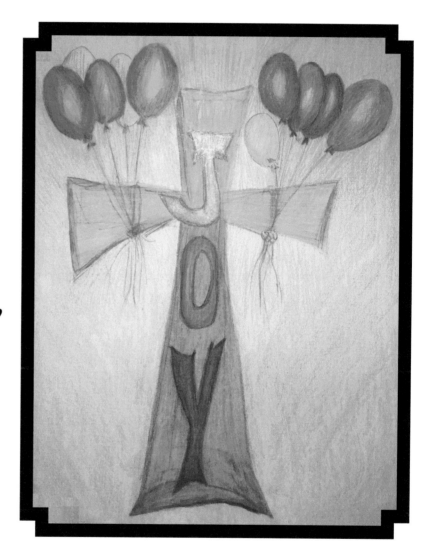

# 30 - You Are My Light

The LORD is my light and my salvation; whom shall I fear? The LORD is the strength of my life; of whom shall I be afraid?

## Psalms 27:1 (KJV)

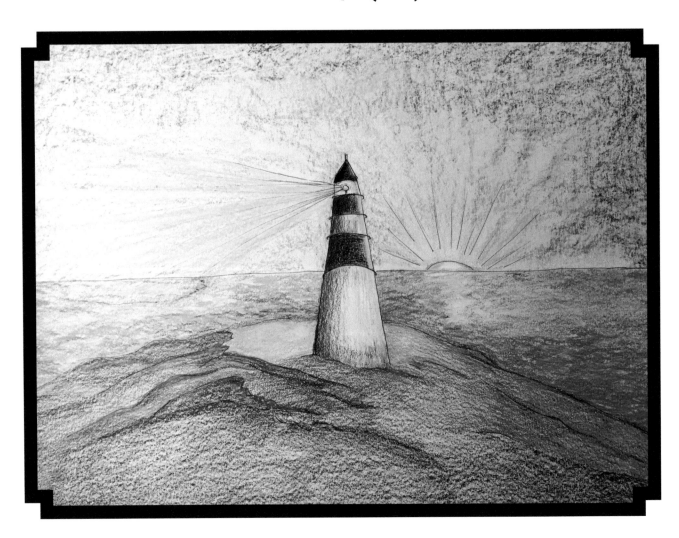

# 31 - Yes and Amen!

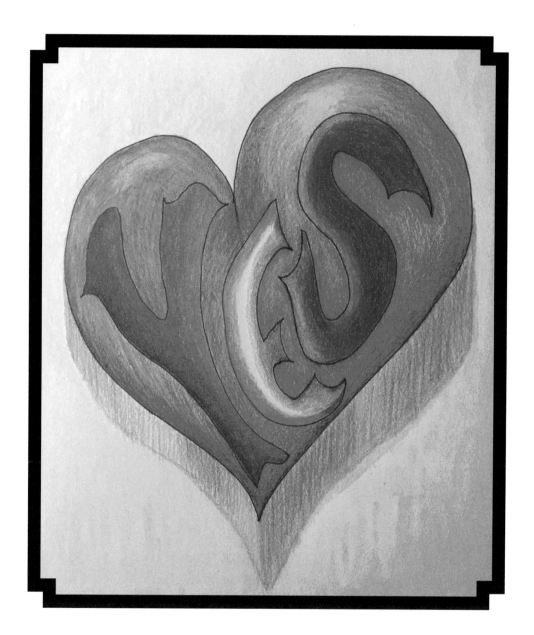

For all the promises of God in him are yea, and
in him Amen, unto the glory of God by us.

II Corinthians 1:20 (KJV)

Printed in the United States
by Baker & Taylor Publisher Services